Count Your Blessings
in color

Paraclete Press

with
Sybil MacBeth
author of
Praying in Color

PARACLETE PRESS
BREWSTER, MASSACHUSETTS

2016 First Printing

Count Your Blessings in Color

Copyright © 2016 by Paraclete Press, Inc.

ISBN 978-1-61261-845-6

10 9 8 7 6 5 4 3 2 1

Published by Paraclete Press
Brewster, Massachusetts
www.paracletepress.com

Printed in the United States of America

Coloring and Prayer

When I remember the activities of my childhood, coloring is near the top of the list. Sitting on the kitchen floor with a box of crayons and a new coloring book is vivid in my mind's eye—and nose. Some of my crayons were pristine and whole; the favorite red one was battered and broken, paper torn to release more color. I loved their waxy crayon smell, but the acrid smell of the newsprint pages in the coloring book made my nose twitch.

Coloring was both work and play. Choosing the colors I wanted to use and trying to stay within the lines required decision and attention. Delight at the rainbow of crayon shades in the box and on my paper kept me coloring for hours. Although some people say that coloring books stifle creativity, the shapes enclosed by lines can be a starting place for creativity. For those of us who are drawing-phobic or intimidated by the vastness of a blank piece of paper, a coloring page is a safe invitation to play with the tools of an artist without having to be one.

I still play and create through coloring. But it has become more for me. It is a starting place for prayer. A dozen or so years ago, family members and friends were diagnosed with a multitude of cancers. I tried to pray for them, but my words became lost in a dark cloud of worry and what-ifs. I prayed a barrage of one-liners: "Please heal her." "Please let him feel no pain." "Please comfort them." My prayers felt small and inadequate.

One day I was doodling and coloring for fun and realized I had written a name in the middle of a doodle. It was the name of my sister-in-law Sue who had stage-four lung cancer. I continued to doodle and color. Her name became the center of my attention. After five or ten minutes, I realized I was praying for Sue. I didn't have articulate or elegant prayer words, but I was spending time with her and releasing her into God's care. For those minutes my worry decreased and I felt God's presence. I added and colored other shapes with people's names in them. At the end of the doodling and coloring session, I had a page of designs and names—a visual prayer list and journal of my prayer time. Every time I looked at the page it reminded me to pray for each person again—with or without words. Praying this way is the closest I have ever come to "praying unceasingly."

Coloring is both prayerful and playful. It gives me a new way to be with God and the permission to not have words. With a handful of colored markers and pencils I become childlike—a useful attitude for prayer. While my hand and eyes move across a coloring page, my mind and body slow down. I enter a proverbial prayer closet, carving out a space and place for silence and an opportunity for God to speak.

When I first included doodling and coloring in my prayer time, I prayed for other people—intercessory prayers. Since then, I've added all different kinds of prayer: giving thanks, praying for others, confessing, praising, worshiping, brooding, complaining, contemplating Scripture, lamenting, asking for help, looking for guidance. . . .

Coloring Your Blessings

The coloring pages in *Count Your Blessings in Color* are designed specifically for prayers of thanksgiving and gratitude. Use them to record your blessings and to listen in a visual and creative way to what they may have to tell you.

To begin your gratitude prayer period, start with some time focused on God. Choose a name for God such as Amazing God, Generous God, Provider, Source of All, Higher Power, Giving One—whatever works best for you. Write the name in a space in the design. Color around it. Think of each stroke of color as a nonverbal prayer. Spend time being quiet while you color. Feel free to pray with words, too, asking God to be present in this prayer time.

Then write your thanksgiving words in the spaces. You can concentrate on one blessing at a time, coloring as you go; or you can brainstorm a bunch and then color. Writing the words, coloring, and listening can start a conversation with God. The quantity of things you include on your page is not important. This is not a contest with others or yourself about gratitude. It is an opportunity to honor the simple and the significant. What might these words have to say to you? What is God saying to you?

Prompts for Blessing Prayers

Often, the words will just flow. When that happens, just write down what comes, whatever it is you are feeling grateful for. Don't force them into a category. For those times when you need a little prompt, though, consider one of these categories:

- Family
- Foods you love, and those that nourish even if you don't like them
- Teachers, mentors, and coaches
- People who have died who were important to you
- People who have said what you needed to hear
- Colors, something we take for granted—draw with those colors on your page
- Some days it's hard to see anything as a blessing. So start simple. Sit in your kitchen, or bedroom, or looking out a window, or any other place. Maybe the words *gratitude* and *blessing* feel too important for trivial things, but being glad for or pleased with the everyday and ordinary is a form of gratitude. Write down the most basic of things you are glad for: plates, salt and pepper, a sharp knife. . . .
- Characters in the Bible who have influenced or taught you
- Activities in your life: book club, soccer league, church, recovery group. . . .
- Pets
- This one is for a grouchy day. On the sheet opposite the coloring design, write disgruntled words, complaints, bad attitudes. After you have unloaded, go to the coloring page and start coloring. Don't even try to counteract the grumblings from the other page. Just color and give it to God.
- Gifts of this season of the year
- Alphabet Prayer: Think of something you are grateful for starting with each letter of the alphabet, or multiple things starting with just one letter.
- Bad things from the past that paid forward good things
- Your body parts and what they do for you
- The gifts of the city or town where you live
- The gifts of your country
- Things about Jesus you are grateful for
- Books that have delighted, inspired, or taught you
- Your work or job—this could include complaints on the facing page

—Sybil MacBeth

When upon life's billows

you are tempest tossed,

When you are discouraged, thinking all is lost,

Count your many blessings, name them one by one,

And it will surprise you what the Lord hath done.

Count your blessings, name them one by one,

Count your blessings, see what God hath done!

—from the hymn "COUNT YOUR BLESSINGS"
by Johnson Oatman Jr.

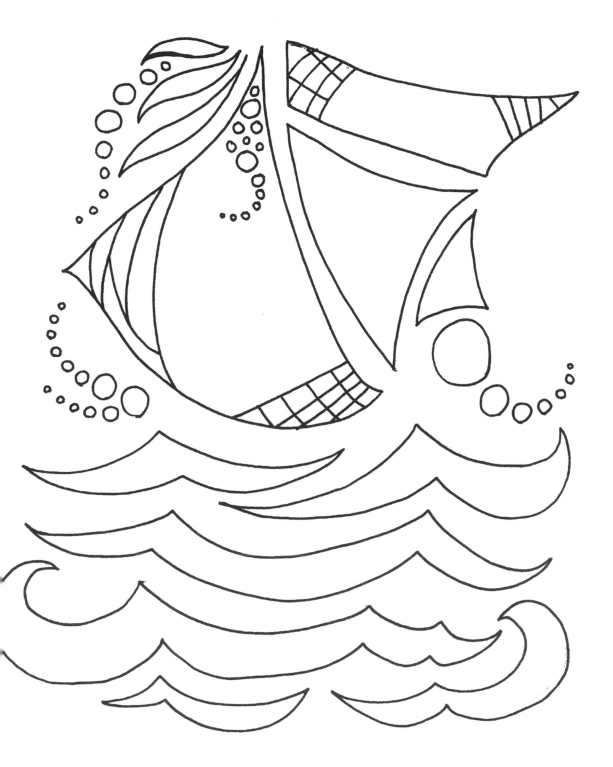

This is the day that the LORD has made;
let us rejoice and be glad in it.

—PSALM 118:24

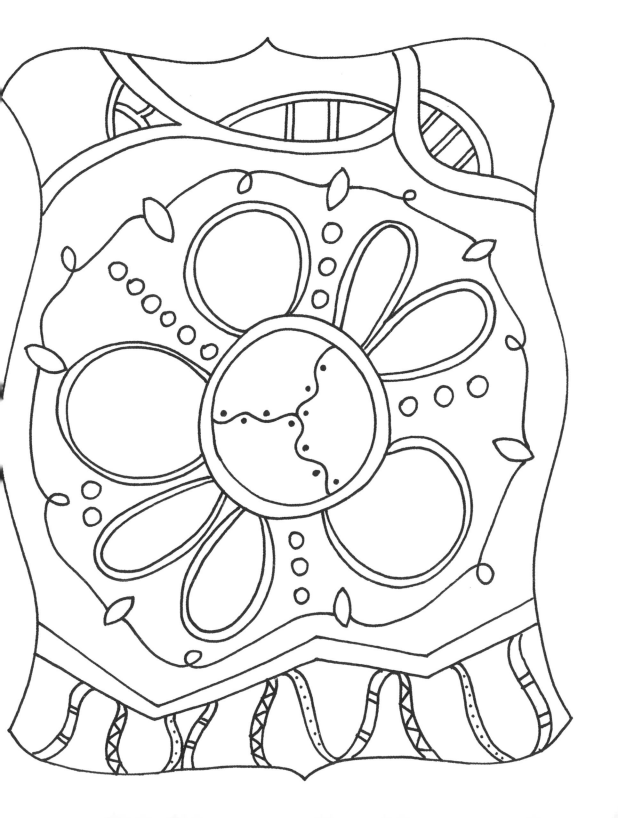

If the only prayer you ever say in your entire life is thank you, it will be enough.

—MEISTER ECKHART

Wilkie said, "Sit right down at this table. Here is a yellow pad and a ballpoint pen. I want you to write down your blessings." . . . The ship of my life might or might not be sailing on calm seas. The challenging days of my existence might or might not be bright and promising. From that encounter on, whether my days are stormy or sunny and if my nights are glorious or lonely, I maintain an attitude of gratitude. If pessimism insists on occupying my thoughts, I remember there is always tomorrow. Today I am blessed.

—MAYA ANGELOU
Mom & Me & Mom

Only he who gives thanks for little things receives the big things. We prevent God from giving us the great spiritual gifts He has in store for us, because we do not give thanks for daily gifts.

—DIETRICH BONHOEFFER

Life Together

The magnificent creativity of God and our awe at the lavishness of life lead us to an awareness of who we really are. Knowing that we are invited guests to the banquet of life fuels the virtue of *humility* that grounds all gratitude.

—ALBERT HAASE, OFM,
Catching Fire, Becoming Flame

Rejoice always, pray without ceasing, give thanks in all circumstances

—1 THESSALONIANS 5:16–18A

Gorgeous, amazing things come into our lives when we are paying attention: mangoes, grandnieces, Bach, ponds. This happens more often when we have as little expectation as possible. If you say, "Well, that's pretty much what I thought I'd see," you are in trouble. . . . Unto us, so much is given. We just have to be open for business.

ANNE LAMOTT
Help Thanks Wow: The Three Essential Prayers

I'm so thankful to live in this physical, messy, blood-and-guts world. I don't want to live in a world that's all dry ideas and theorems. Food is one of the ways we acknowledge our humanity, our appetites, our need for nourishment. And so it may seem trivial or peripheral to some people, but to me, when I'm telling a story, the part about what we ate really does matter.

—SHAUNA NIEQUIST, *Bittersweet*

To be grateful is to recognize the Love of God in everything He has given us—and He has given us everything.

—THOMAS MERTON, *Words of Gratitude*

Birth: wonder ... astonishment ... adoration.
There can't be very many of us for whom the sheer
fact of existence hasn't rocked us back on our heels.
We take off our sandals before the burning bush. We
catch our breath at the sight of a plummeting hawk.
"Thank you, God." We find ourselves in a lavish
existence in which we feel a deep sense of kinship—
we belong here; we say thanks with our lives to Life.
And not just "Thanks" or "Thank It" but
"Thank *You*."

—EUGENE PETERSON, in *God with Us*

I will give thanks to the LORD with my whole heart; I will tell of all your wonderful deeds.

—PSALM 9:1

The choice of gratitude rarely comes without some real effort. But each time I make it, the next choice is a little easier, a little freer, a little less self-conscious. Because every gift I acknowledge reveals another and another, until finally even the most normal, obvious, and seemingly mundane event or encounter proves to be filled with grace.

—HENRI J. M. NOUWEN,
The Return of the Prodigal Son

I believe the old practice of pausing to thank God before meals is a wise and good one. It reminds me of my creatureliness; like the birds of the air and the flowers of the field, I am dependent on God for my daily sustenance.

—BRIAN D. MCLAREN, *Naked Spirituality*

There are only two ways to live your life.

One is as though nothing is a miracle. The other is as

though everything is a miracle.

—ALBERT EINSTEIN

Everything that has been created by God is good, and nothing that is received with thanksgiving should be rejected.

—1 TIMOTHY 4:4 (CEB)

Be glad of life because it gives you the chance to love and to work and to play and to look at the stars.

—HENRY VAN DYKE

If every moment of existence is a grace, we can simply rest in God. It means our joy might just transcend our circumstances.

—JANA RIESS, *Flunking Sainthood*

I thank God for my handicaps, for, through them I have found myself, my work, and my God.

—HELEN KELLER

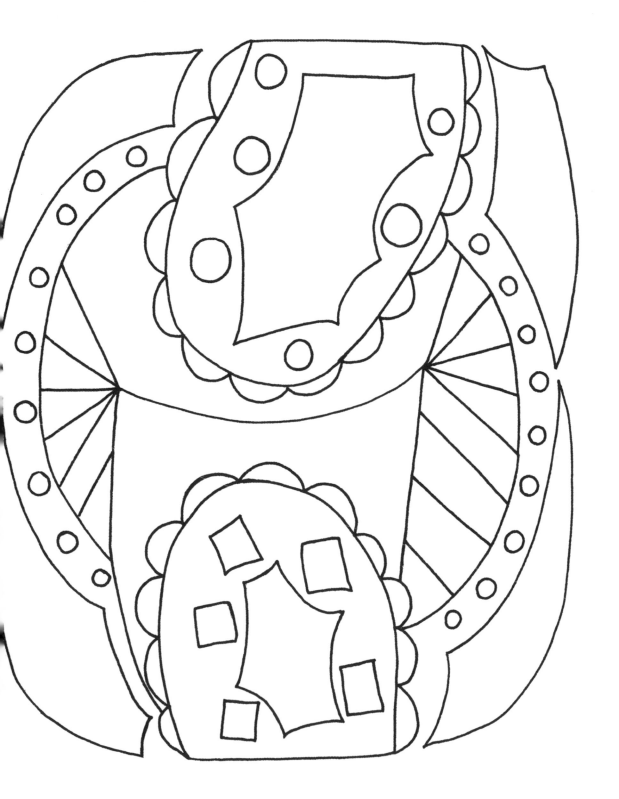

Gratitude is not only the greatest of
virtues, but the parent of all the others.

—CICERO

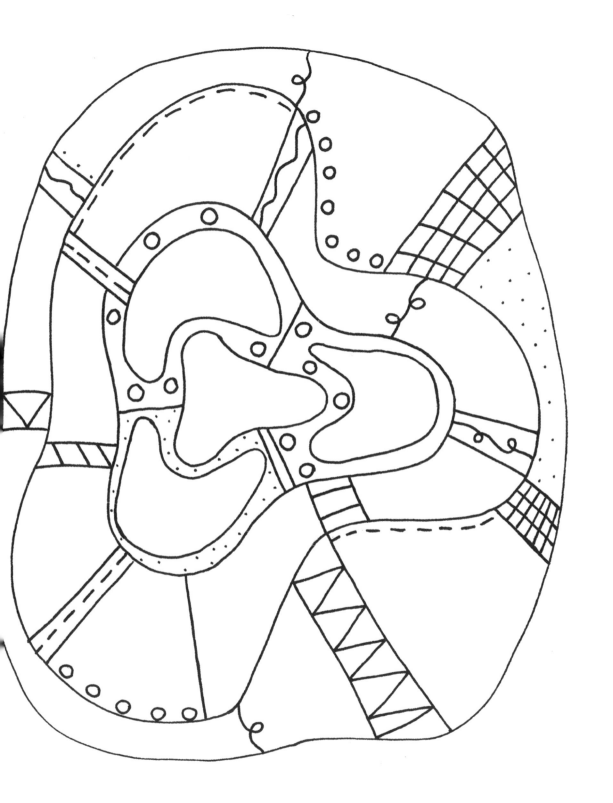

The whole earth is filled with awe at your wonders; where morning dawns, where evening fades, you call forth songs of joy.

—PSALM 65:8 (NIV)

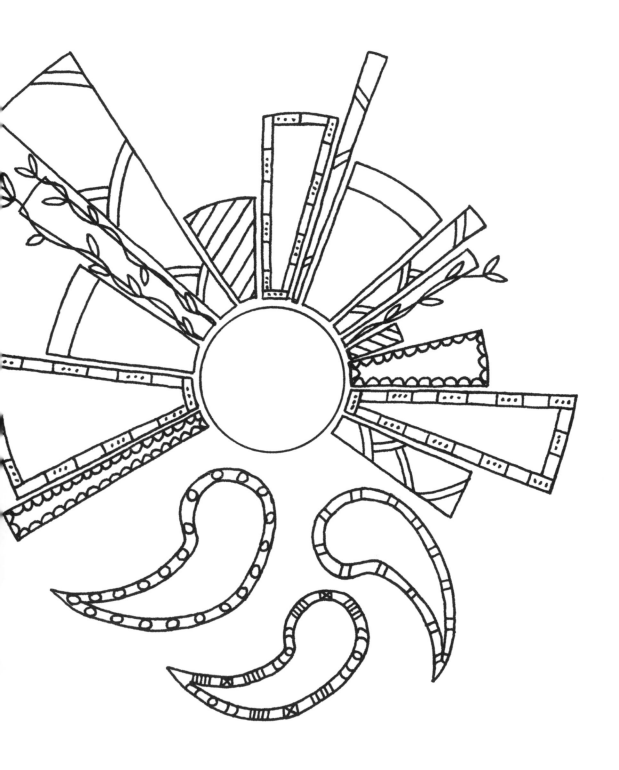

I thank you, my God, for having in a thousand different ways led my eyes to discover the immense simplicity of things.

—PIERRE TEILHARD DE CHARDIN, SJ

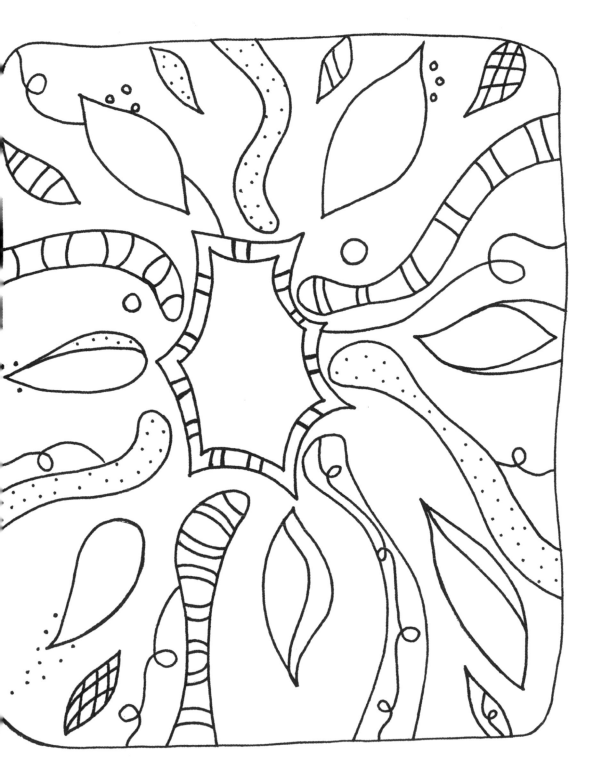

For the beauty of the earth,

For the glory of the skies;

For the love which from our birth,

Over and around us lies;

Lord of all, to Thee we raise

This, our hymn of grateful praise.

—from the hymn "FOR THE BEAUTY OF THE EARTH"
by Folliott S. Pierpoint

To be a saint is to be fueled by gratitude,
nothing more and nothing less.

—RONALD ROLHEISER, *The Holy Longing*

Almost the soul's whole work is to realize
its unworthiness to receive such great good
and to occupy itself in thanksgiving.

—ST. TERESA OF AVILA

Reflect upon your present blessings
of which every man has many
—not on your past misfortunes,
of which all men have some.

—CHARLES DICKENS

A Prayer of Thanksgiving (for any occasion):

For each new morning with its light,

For rest and shelter of the night,

For health and food,

For love and friends,

For everything Thy goodness sends.

—RALPH WALDO EMERSON

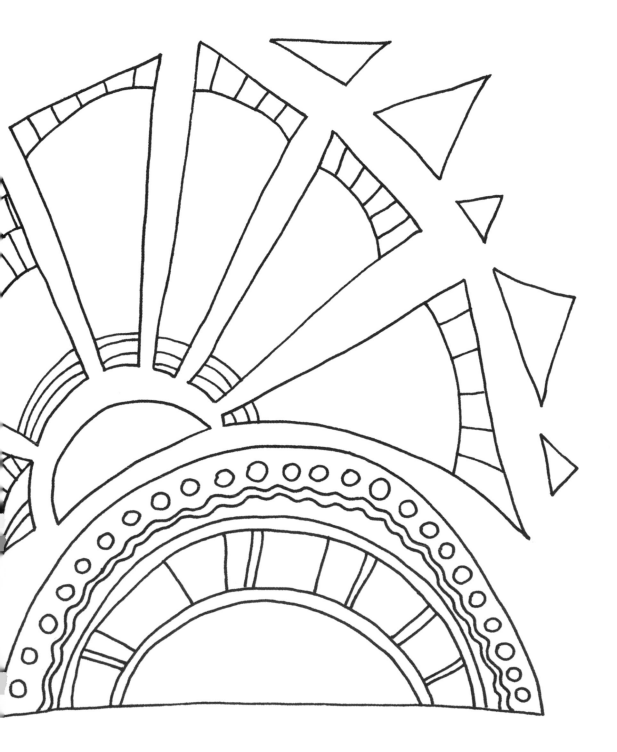

Thankfulness points us away from what we have achieved or failed to achieve and makes us focus instead on God's love, which alone can warm our cold hearts and set them on fire with delight in God and in serving and obeying him.

—RANALD MACAULAY AND JERRAM BARRS,
Being Human

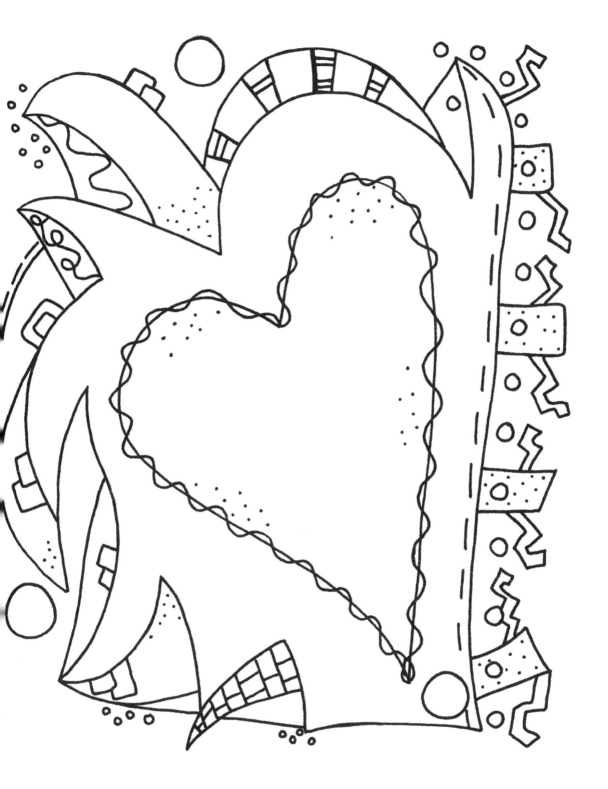

Sources

4. Maya Angelou, *Mom & Me & Mom* (New York: Random House, 2013), 135–37.

5. Dietrich Bonhoeffer, *Life Together: A Discussion of Christian Fellowship* (San Francisco: Harper & Row, 1954), 29.

6. Albert Haase, OFM, *Catching Fire, Becoming Flame* (Brewster, MA: Paraclete Press, 2013), 52.

8. Anne Lamott, *Help, Thanks, Wow: The Three Essential Prayers* (New York: Riverhead Books, 2012), Kindle edition.

9. Shauna Niequist, *Bittersweet* (Grand Rapids, MI: Zondervan, 2010), 39.

10. Thomas Merton, quoted in *Words of Gratitude*, ed. Robert A. Emmons and Joanna Hill (Philadelphia: Templeton Foundation Press, 2001), 14.

11. Eugene Peterson, *God with Us: Rediscovering the Meaning of Christmas*, ed. Greg Pennoyer and Gregory Wolfe (Brewster, MA: Paraclete Press, 2007), 1.

13 and back cover. Henri J. M. Nouwen, *The Return of the Prodigal Son: A Story of Homecoming* (New York: Image/Doubleday, 1994), 86.

14. Brian D. McLaren, *Naked Spirituality: A Life with God in 12 Simple Words* (San Francisco: HarperOne, 2011), 77.

18. Jana Riess, *Flunking Sainthood: A Year of Breaking the Sabbath, Forgetting to Pray, and Still Loving My Neighbor* (Brewster, MA: Paraclete Press, 2011), 120.

22. Pierre Teilhard de Chardin, *Hymn of the Universe* (New York: Harper & Row, 1965), 18.

24. Ronald Rolheiser, *The Holy Longing: The Search for a Christian Spirituality* (New York: Doubleday, 1999), 66.

28. Ranald Macaulay and Jerram Barrs, *Being Human: The Nature of Spiritual Experience* (Downers Grove, IL: InterVarsity Press, 1978), 73.

Learn about Praying in Color *from Paraclete Press . . .*

Praying in Color
Drawing a New Path to God
Sybil MacBeth

ISBN: 978-1-55715-412-9 , $17.99, Paperback

*M*aybe you hunger to know God better. Maybe you love color. "A new prayer form gives God an invitation and a new door," explains Sybil MacBeth. "For many of us, using only words to pray reduces God by the limits of our finite words."

Praying in Color
Kids' Edition
Sybil MacBeth

ISBN: 978-1-55725-595-2, $16.99, Paperback

*N*ow kids can pray in color, too! This first-of-its-kind resource can forever change the way kids talk to God—and how adults try to teach them to pray.

Pray and Color
Sybil MacBeth

ISBN: 978-1-61261-827-2 , $14.99, Paperback

*T*his new coloring book and guide allows anyone to quiet the mind and pray while creating something visual and inspired. Includes an introduction and guide to fourteen types of prayer.

Available through your local bookseller or through Paraclete Press
www.paracletepress.com | 1-800-451-5006

You may also be interested in . . .

Words of Faith:
A Coloring Book to Bless and De-Stress

ISBN: 978-1-61261-767-1 , $11.99, Paperback

*F*or any religious or spiritual seeker, coloring these 30 patterns, each paired with an uplifting Word of Faith and a simple verse, will relax the mind and bless the heart.

Celtic Blessings:
A Coloring Book to Bless and De-Stress

ISBN: 978-1-61261-766-4, $11.99, Paperback

*C*oloring these 30 Celtic patterns not only is a simple path to making something beautiful, but it has a spiritual element as well. Each design is paired with a traditional Irish blessing that will calm your spirit and quiet your mind.

Available through your local bookseller or through Paraclete Press
www.paracletepress.com | 1-800-451-5006